Tayla Blaire

Illustrations by Stephen Barnwell

The Unofficial
WHEEL OF TIME
COLORING BOOK

From the Two Rivers to the White
Tower, Color Your Way Through
the World of the Wheel

Adams Media
New York London Toronto Sydney New Delhi

Adams Media
An Imprint of Simon & Schuster, Inc.
100 Technology Center Drive
Stoughton, Massachusetts 02072

First Adams Media trade paperback edition November 2022

ADAMS MEDIA and colophon are trademarks of Simon & Schuster.

For information about special discounts for bulk purchases, please contact Simon & Schuster Special Sales at 1-866-506-1949 or business@simonandschuster.com.

The Simon & Schuster Speakers Bureau can bring authors to your live event. For more information or to book an event contact the Simon & Schuster Speakers Bureau at 1-866-248-3049 or visit our website at www.simonspeakers.com.

Illustrations by Stephen Barnwell
Images © Simon & Schuster, Inc.

Manufactured in the United States of America

10 9 8 7 6 5 4 3 2 1

ISBN 978-1-5072-1987-4

INTRODUCTION

The safety of the Two Rivers.

The eerie mists of Shadar Logoth.

The power of the White Tower.

Welcome to the epic adventure of The Wheel of Time, where the One Power rules, and forces of good and evil prepare to do battle for the fate of the world—again. From the escape on Winternight to run-ins with the Whitecloaks, the Tinkers, and the Aes Sedai (including the mysterious Moiraine and her Warder, Lan), the compelling and action-packed scenes are brought to life in *The Unofficial Wheel of Time Coloring Book*.

Here you'll have the chance to add your own color to the Pattern as you follow our heroes on their journey to escape the forces of the Dark One and find the identity of the Dragon Reborn. Whether you're a longtime reader or a new viewer eager to spend more time in the quest of the Wheel, this coloring book will provide you with hours of fun and relaxation with forty-five detailed scenes to bring to life, including:

+ Perrin, Rand, and Mat at the Winespring Inn
+ Nynaeve's traveling apothecary
+ Our group of heroes at the Waygate
+ Skulls in the Blight
+ Seanchan on the western shore
+ And more!

Arm yourself with your weapon of choice (colored pencils, crayons, or markers all work well), and escape into a high fantasy adventure with *The Unofficial Wheel of Time Coloring Book*!

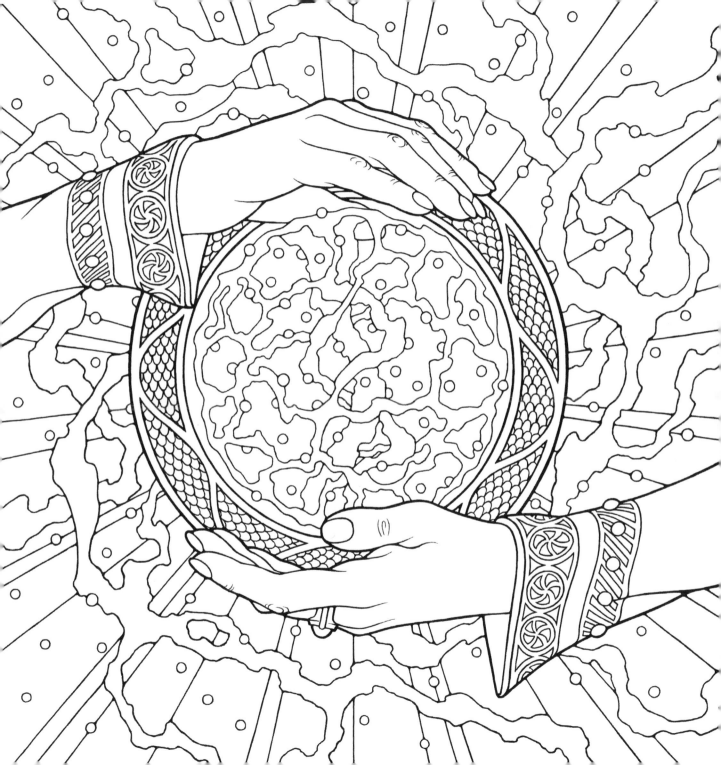

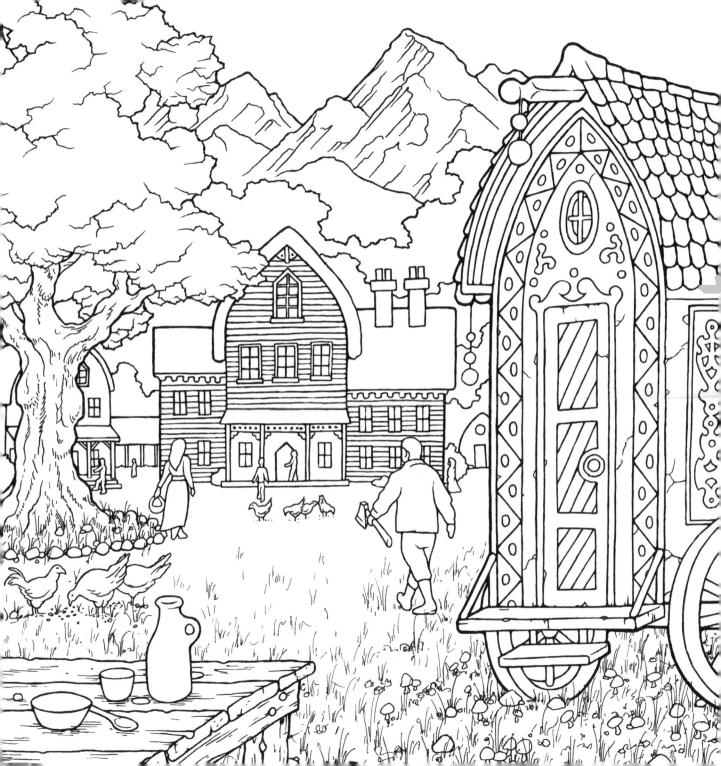

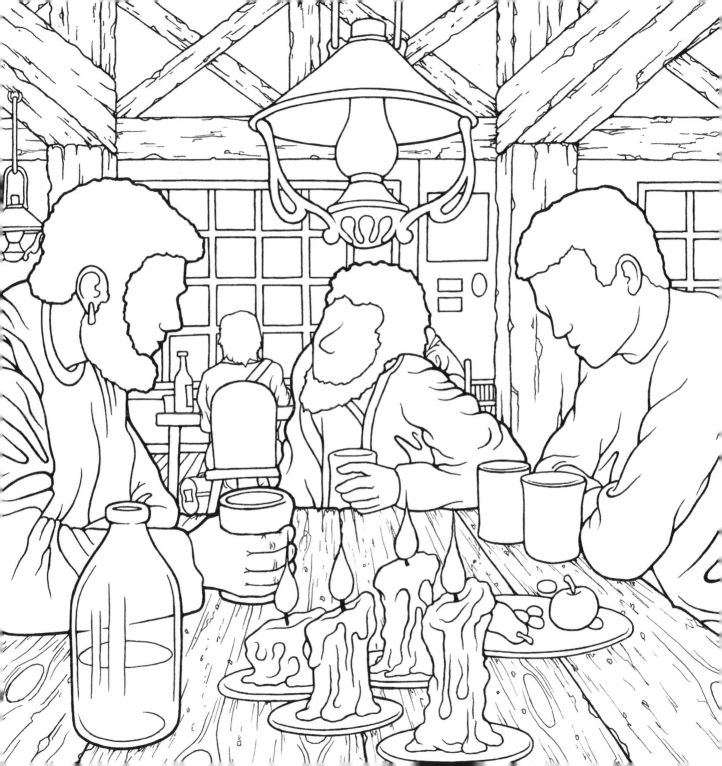

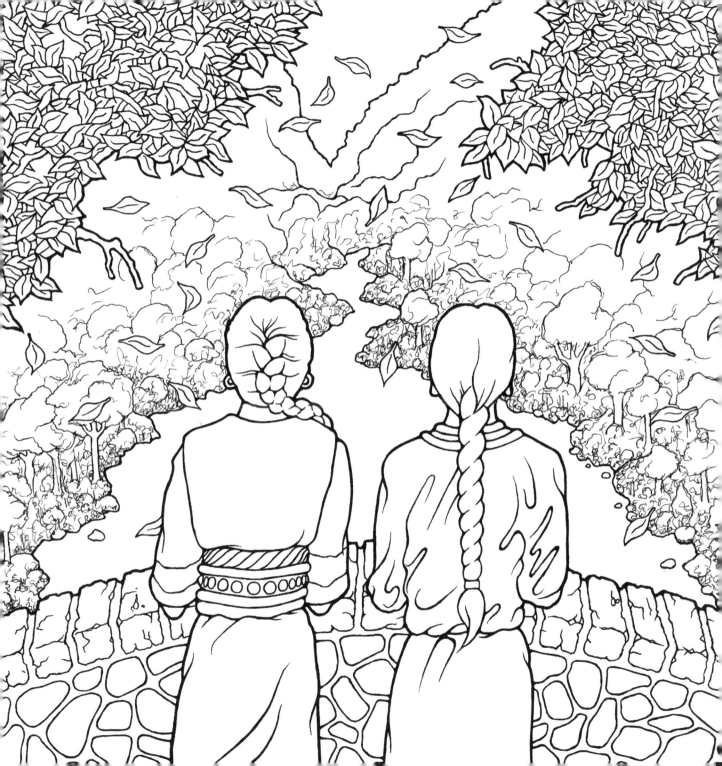

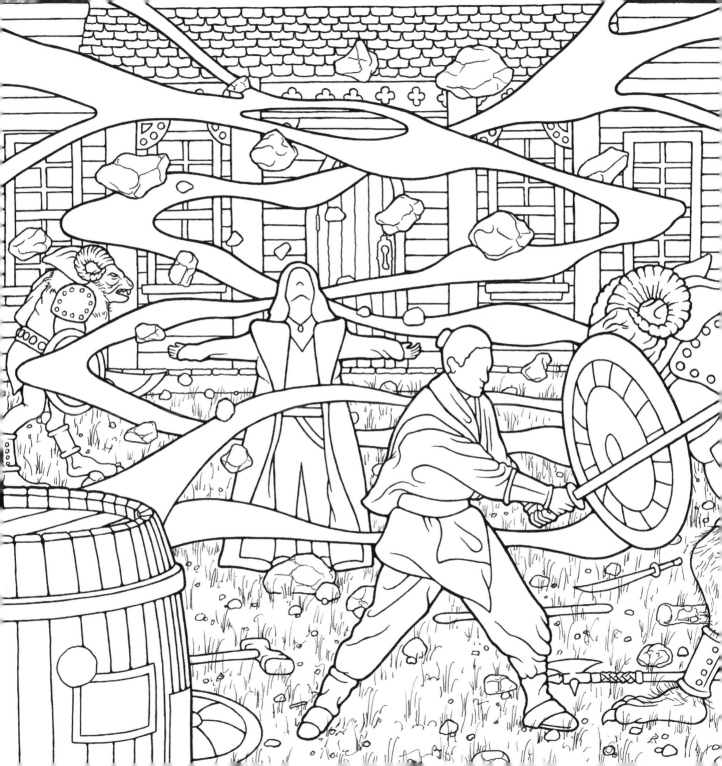

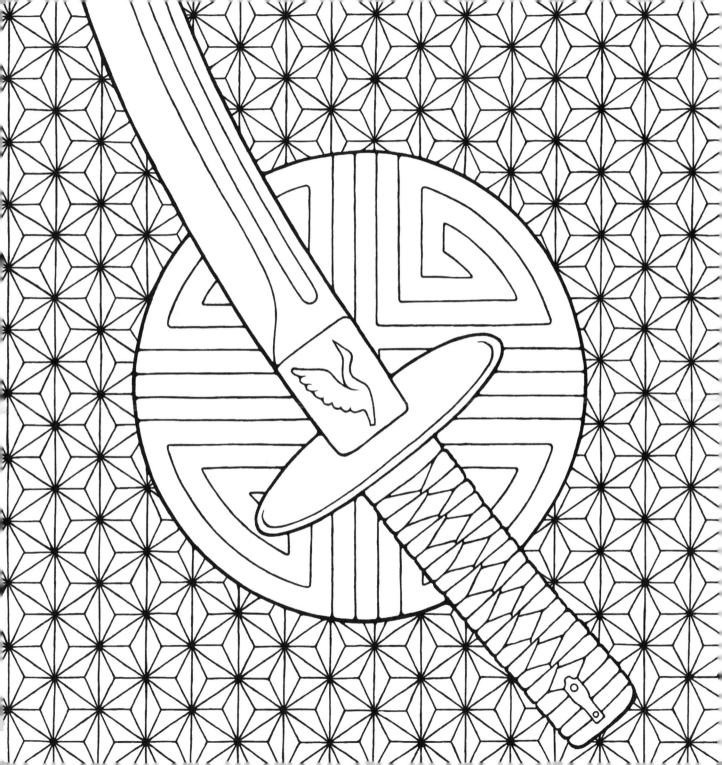

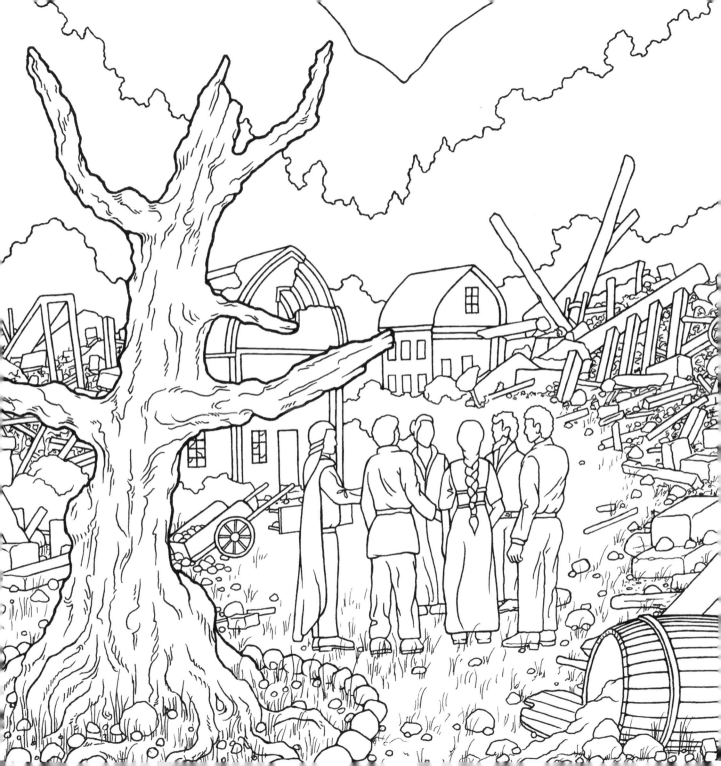

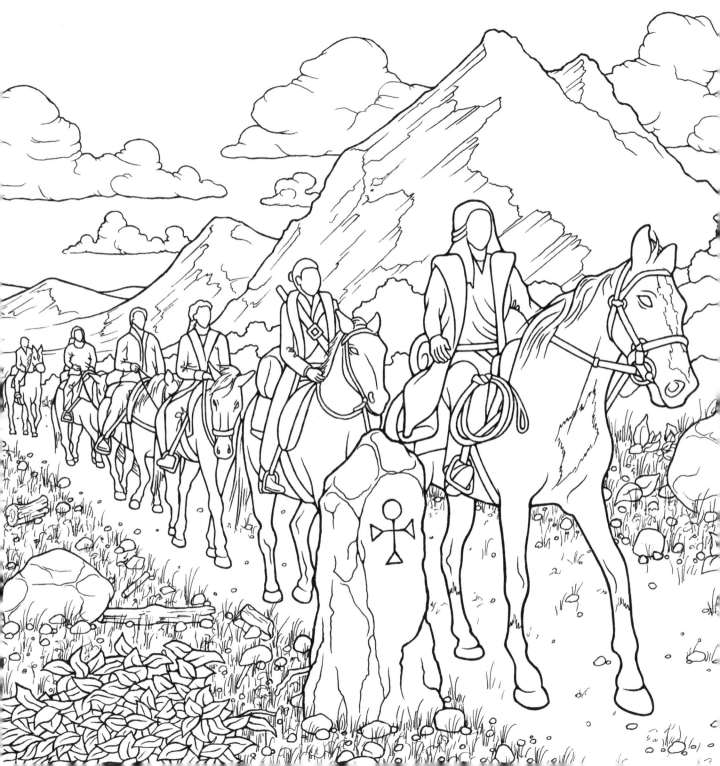

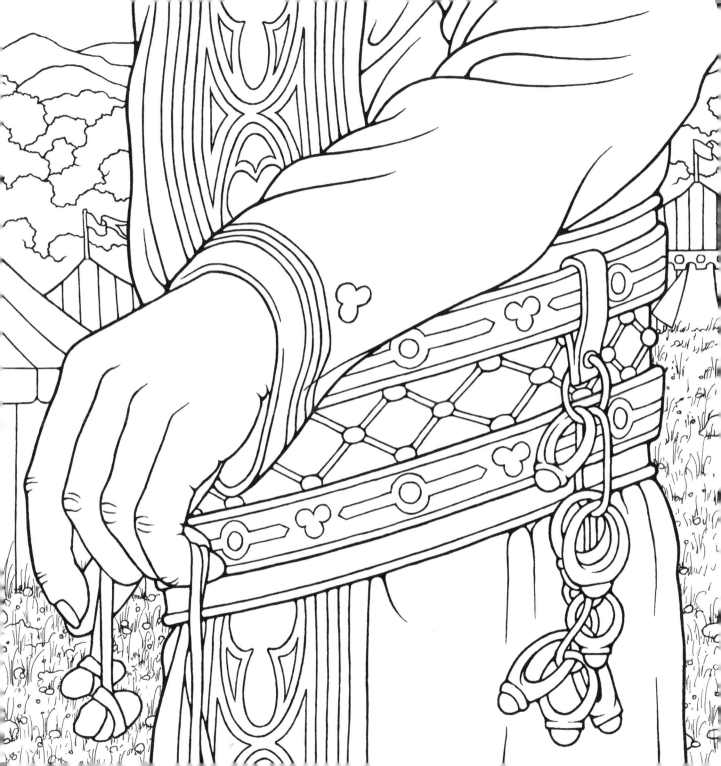

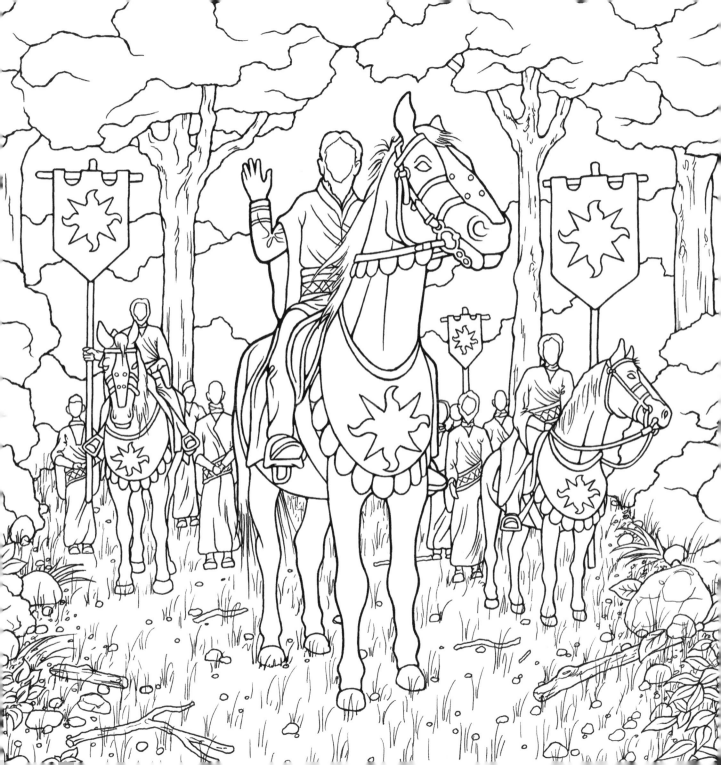

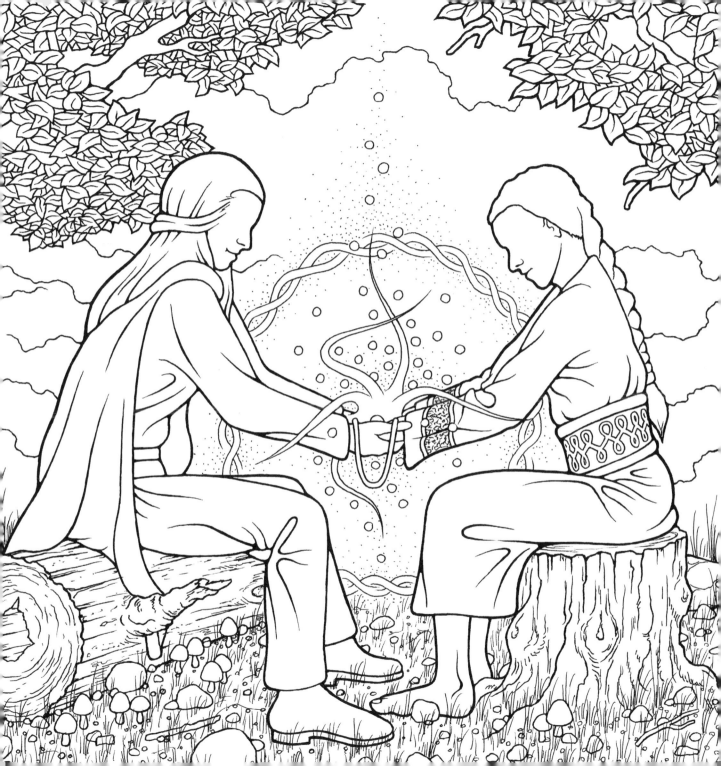

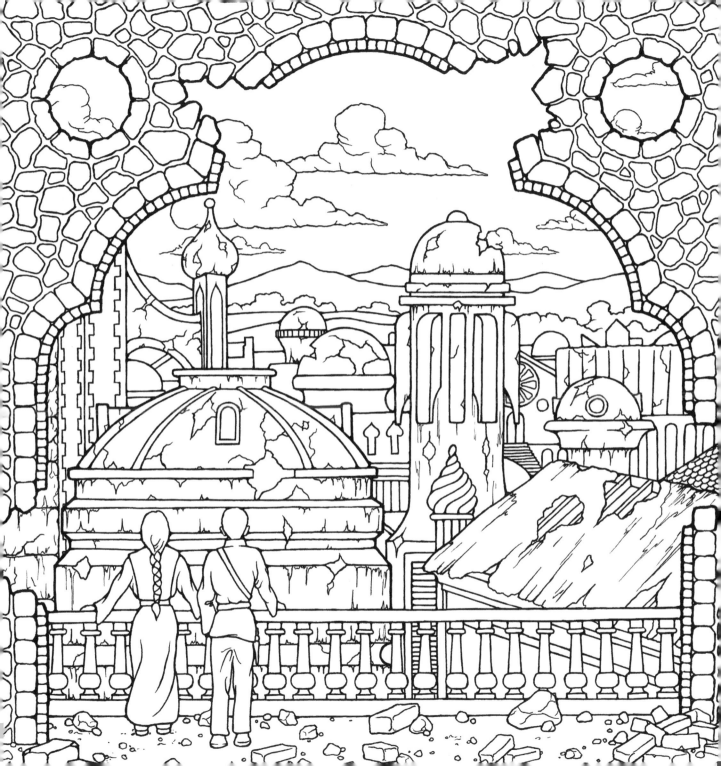

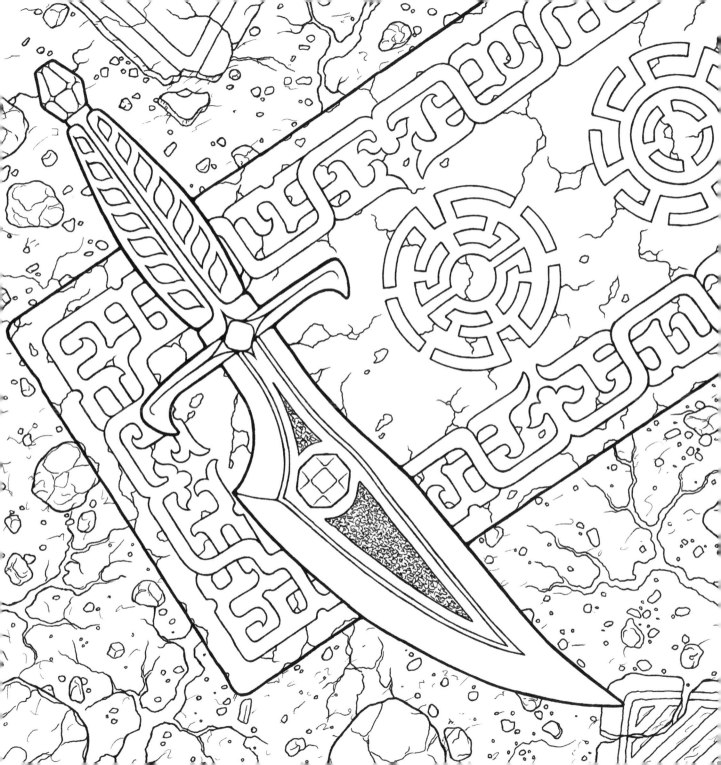

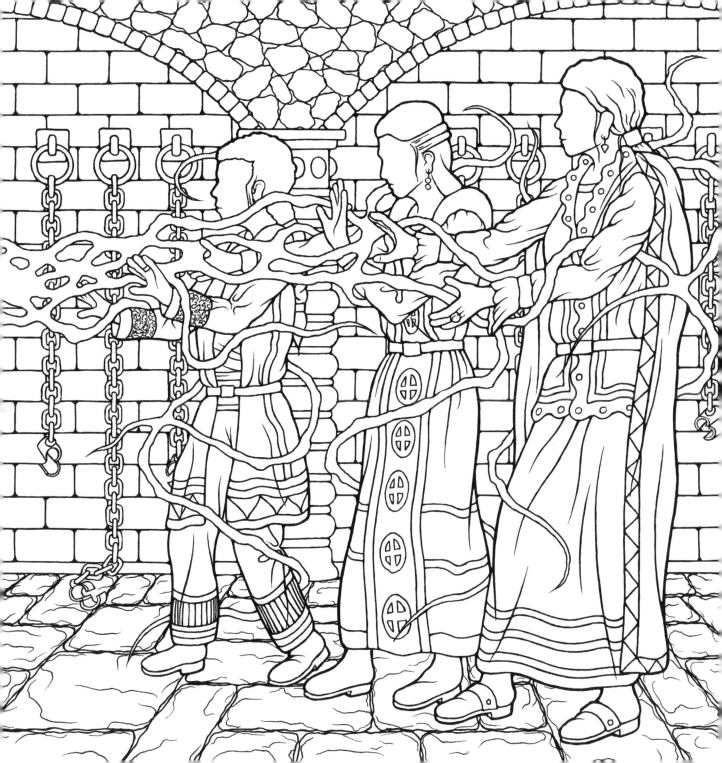

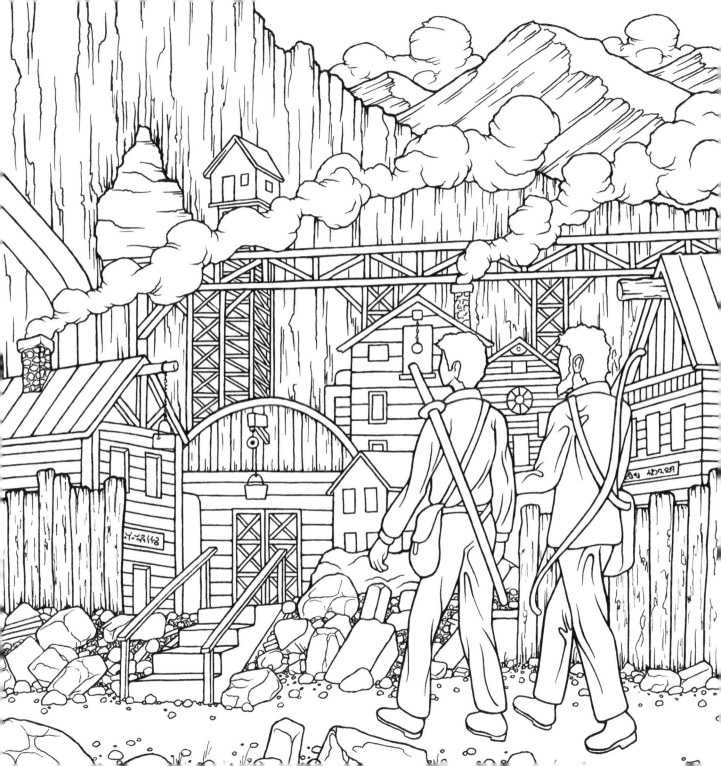

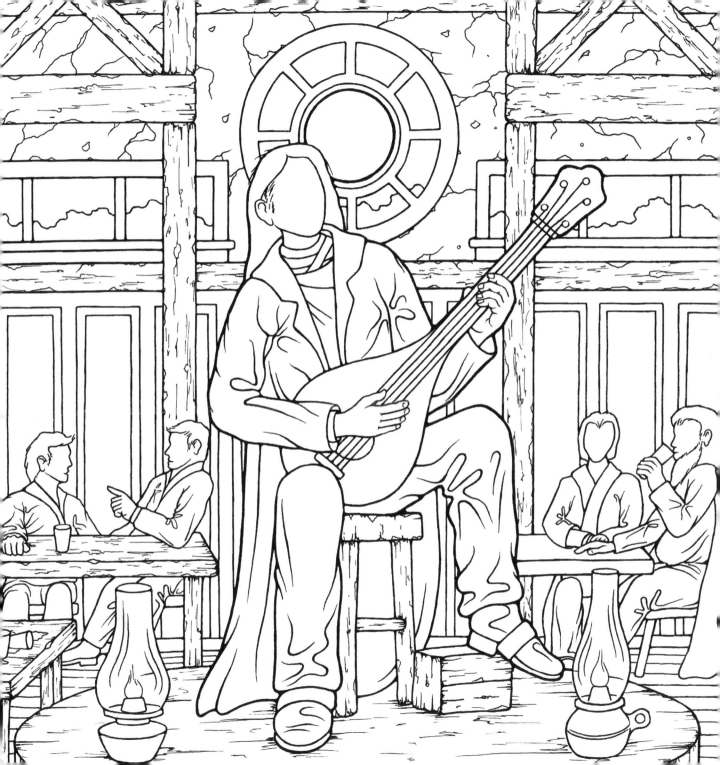

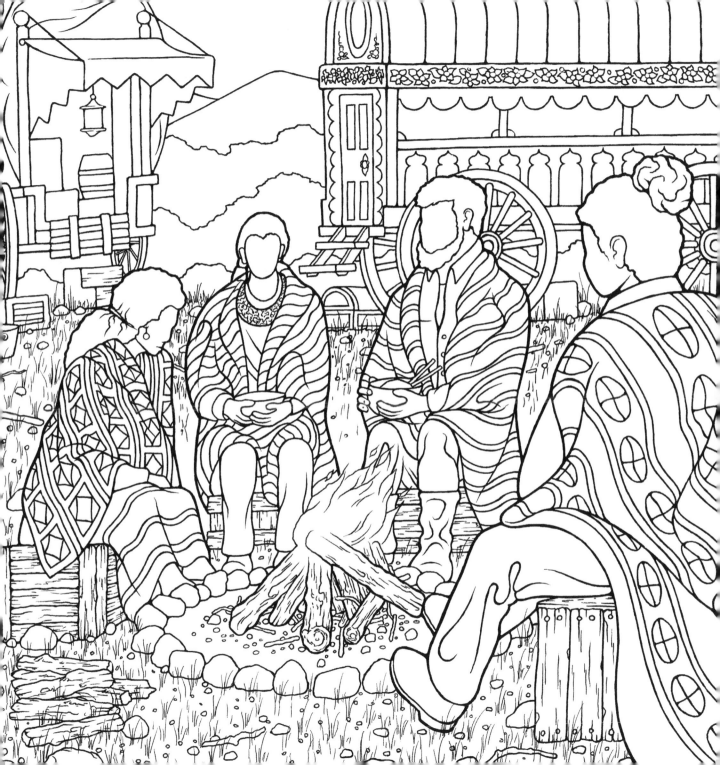

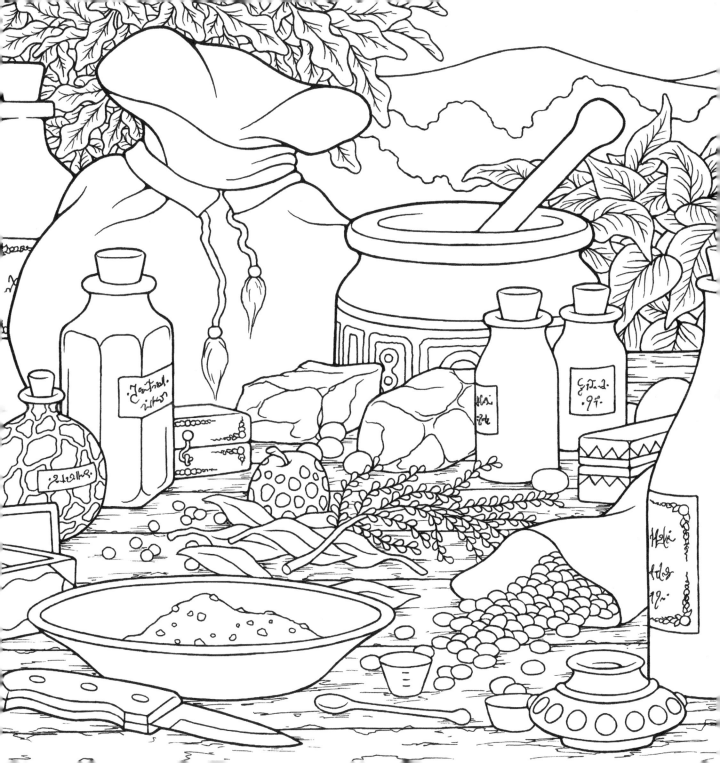

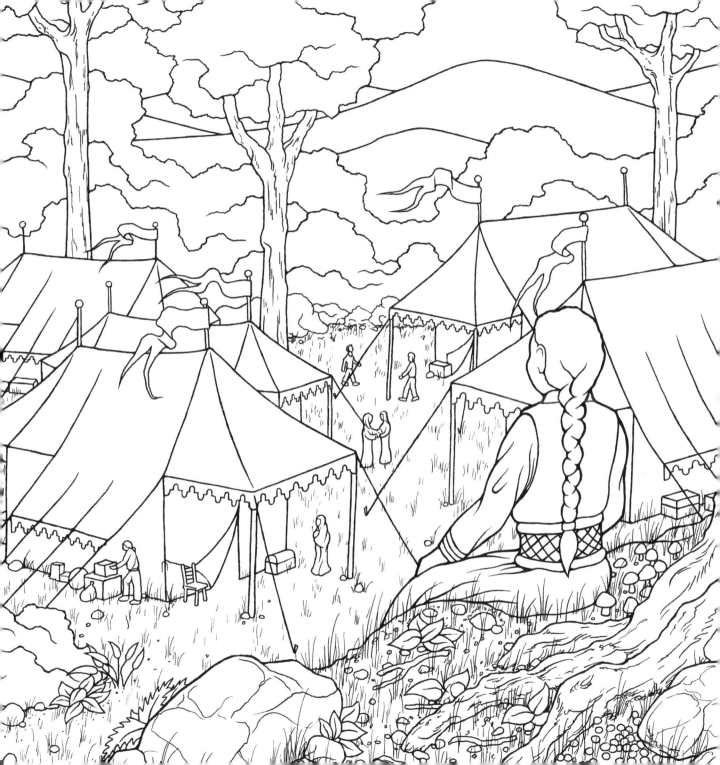

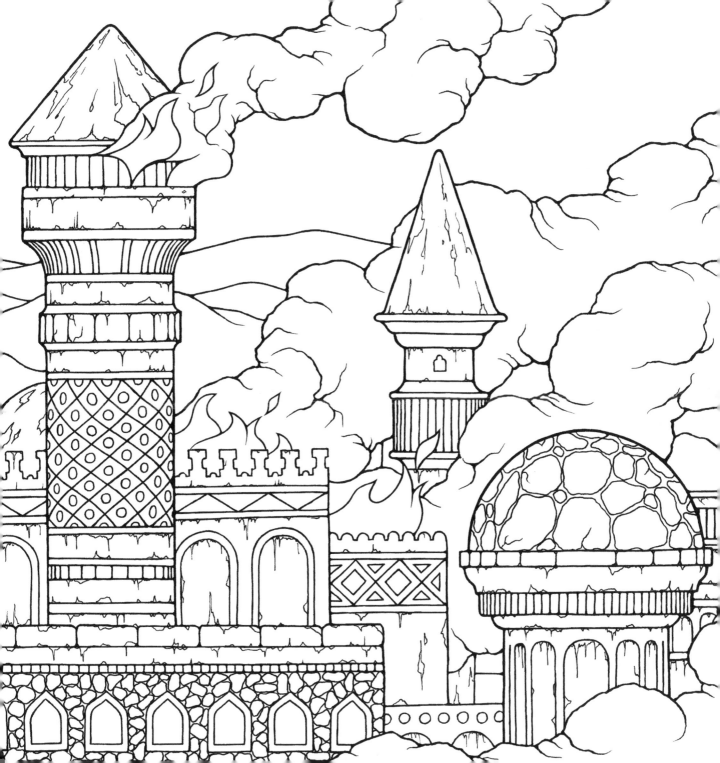

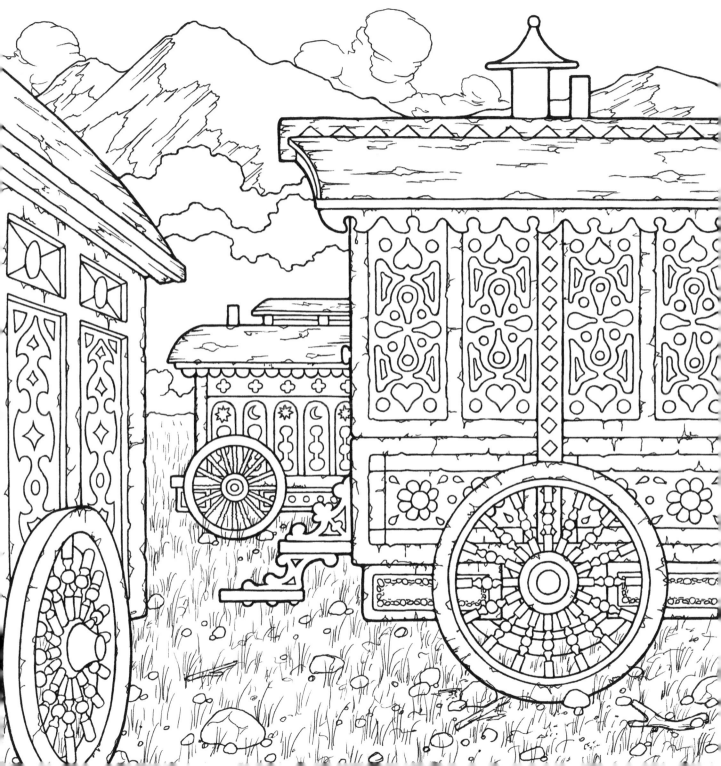

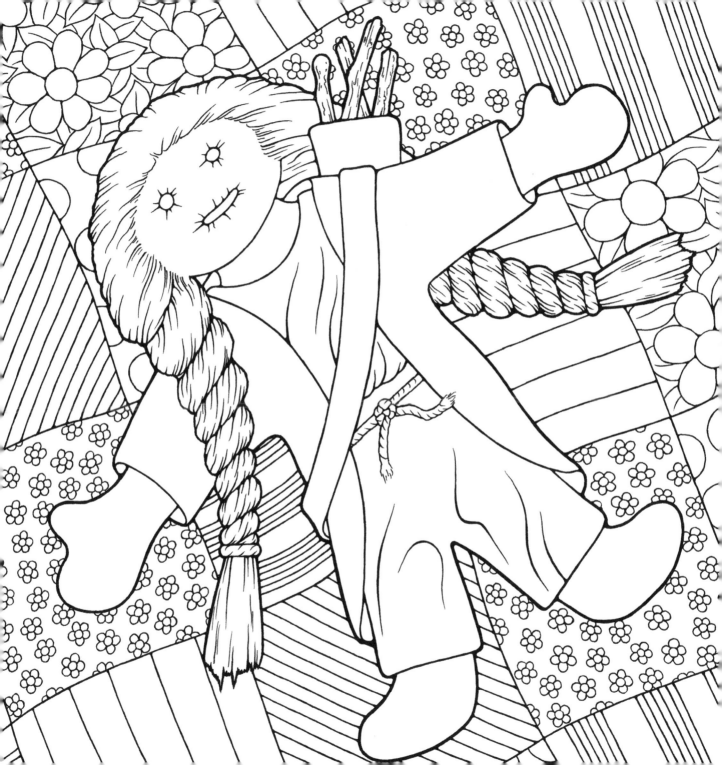

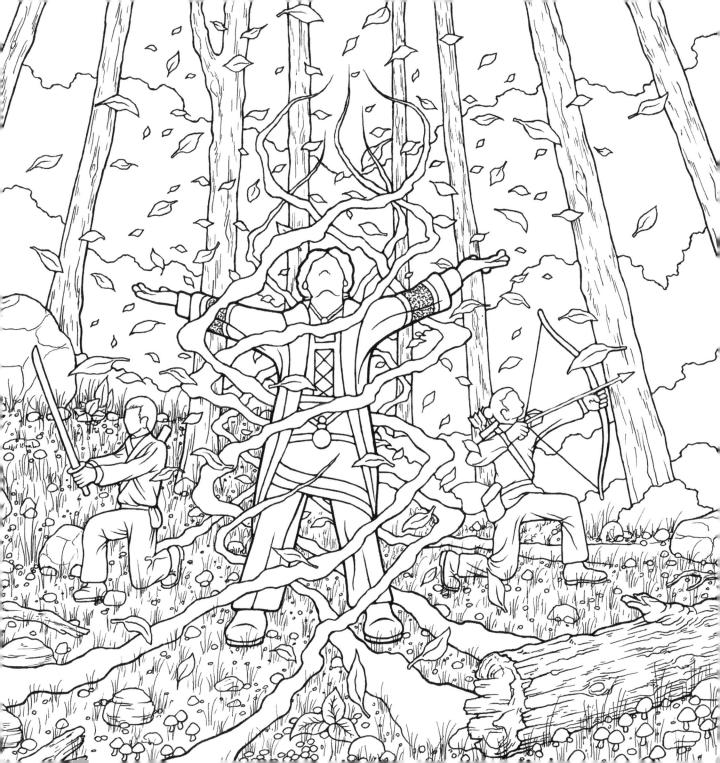

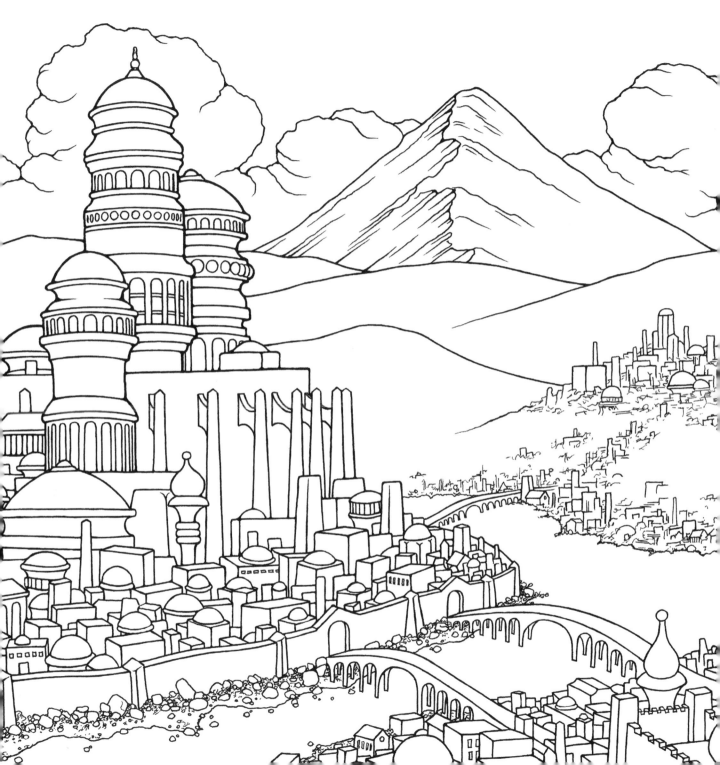

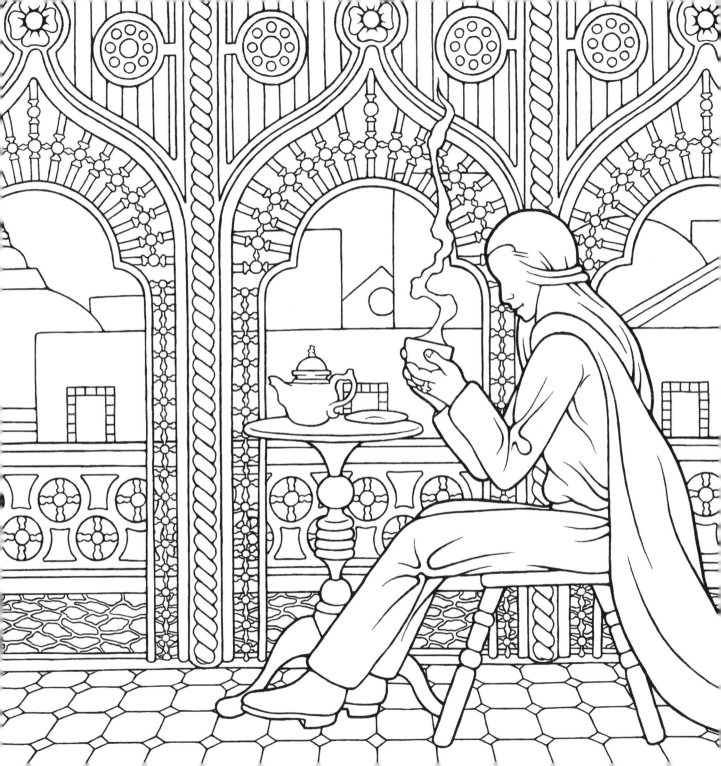

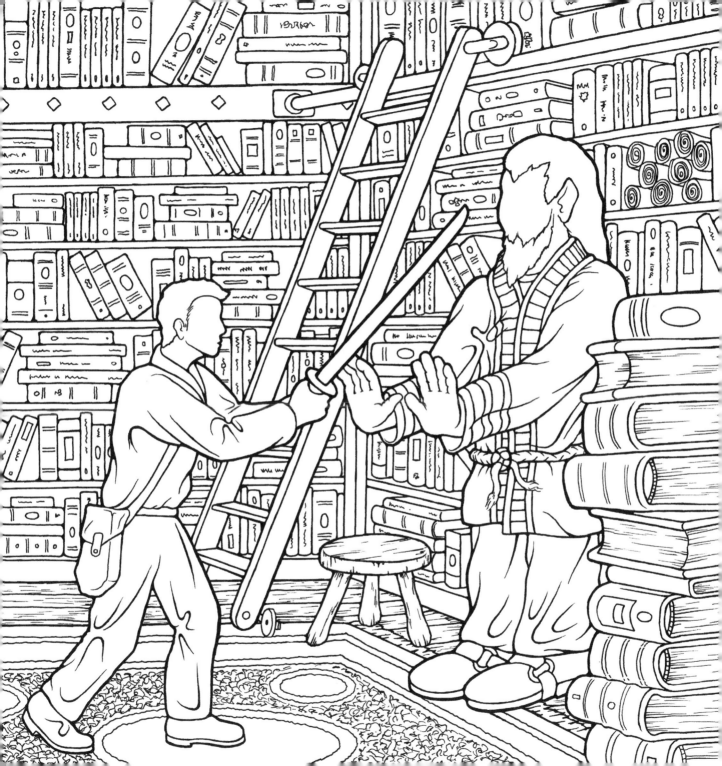

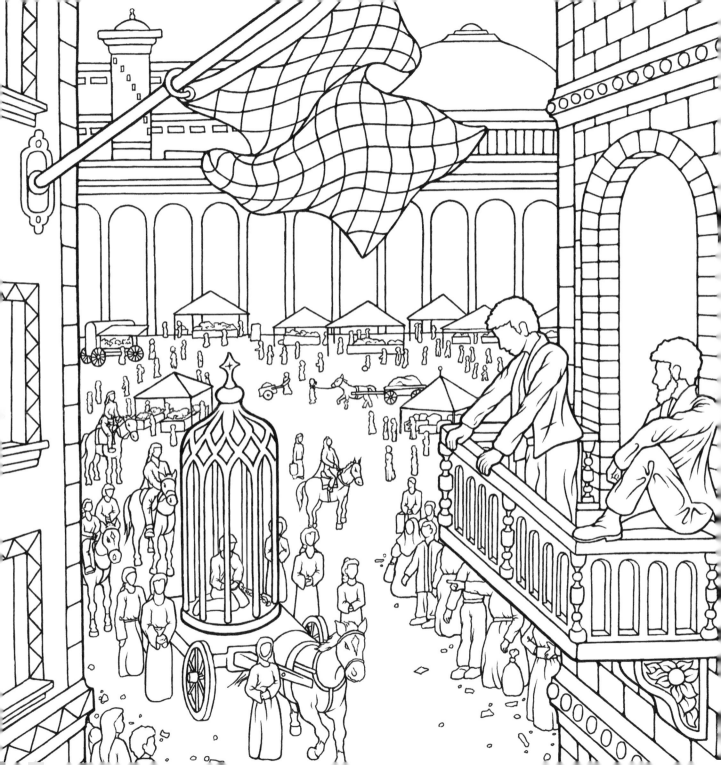

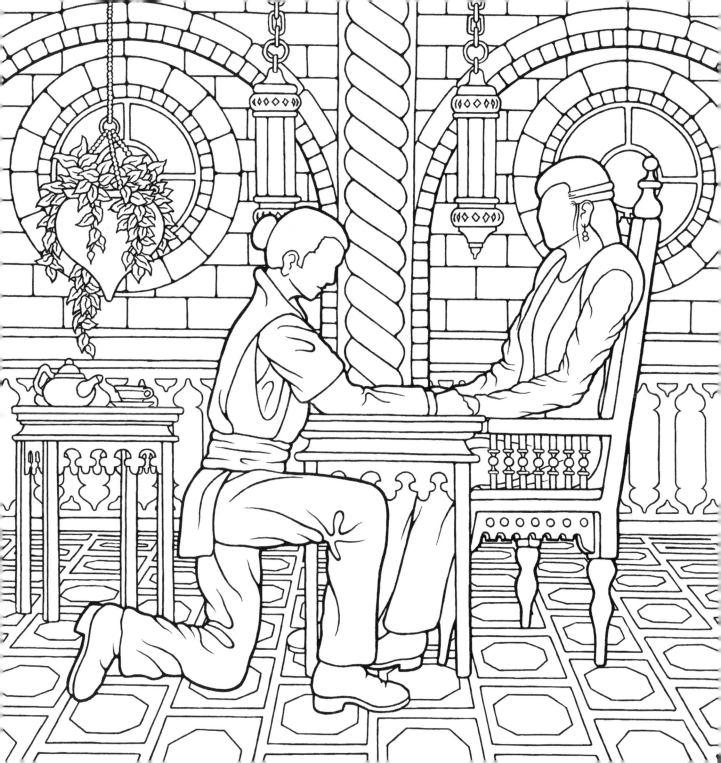

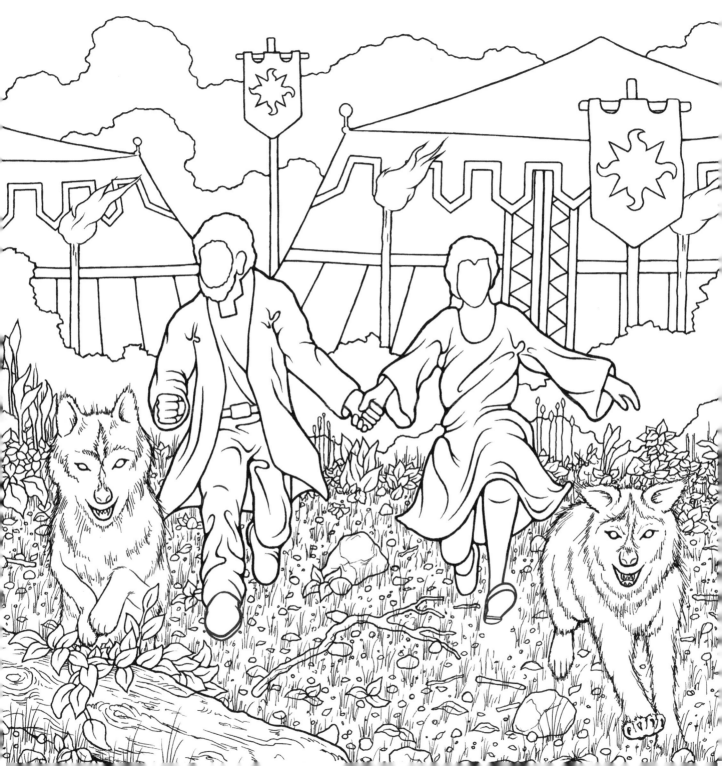

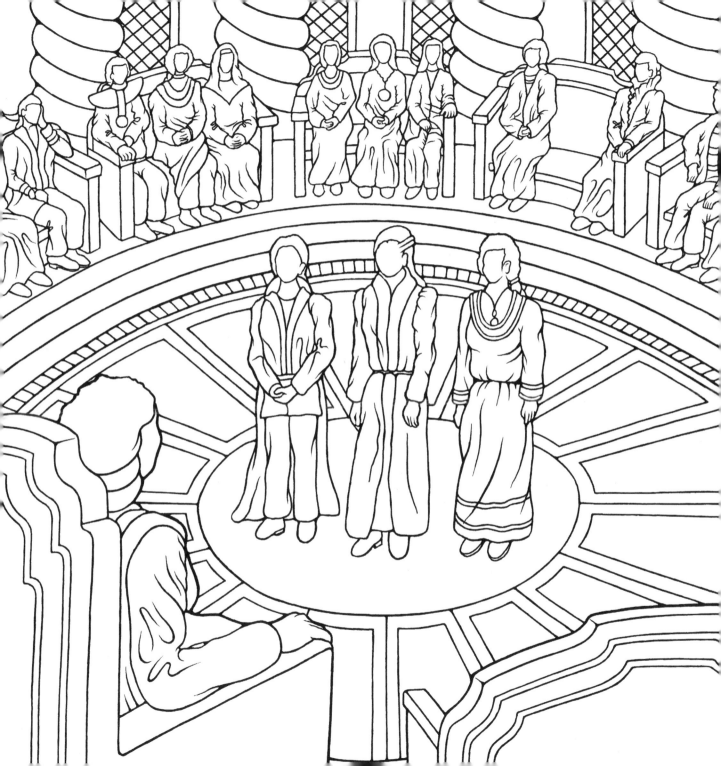

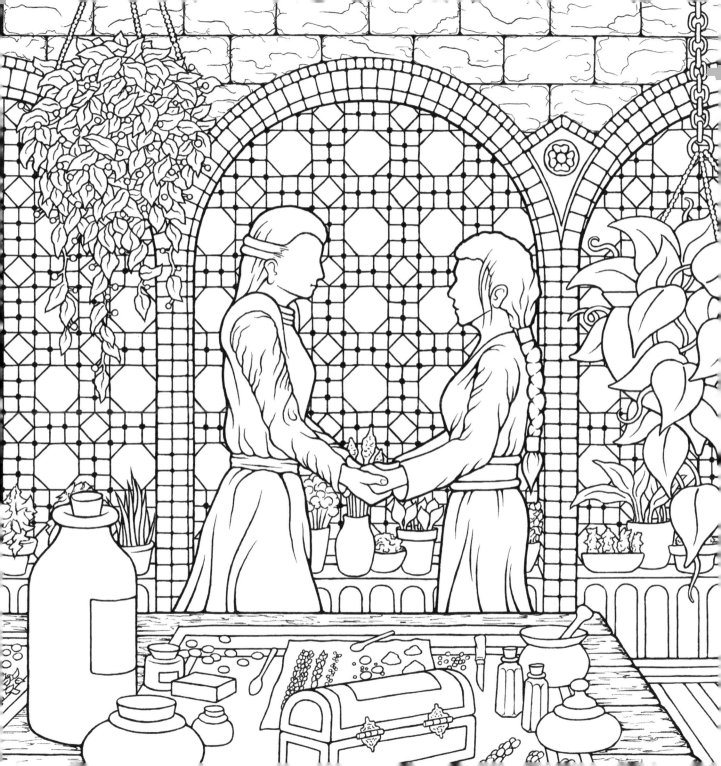

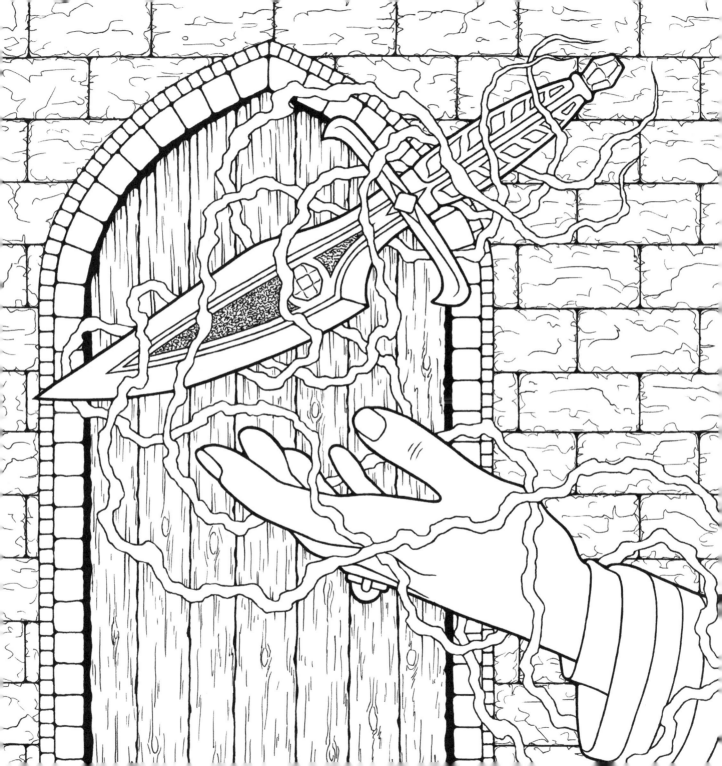

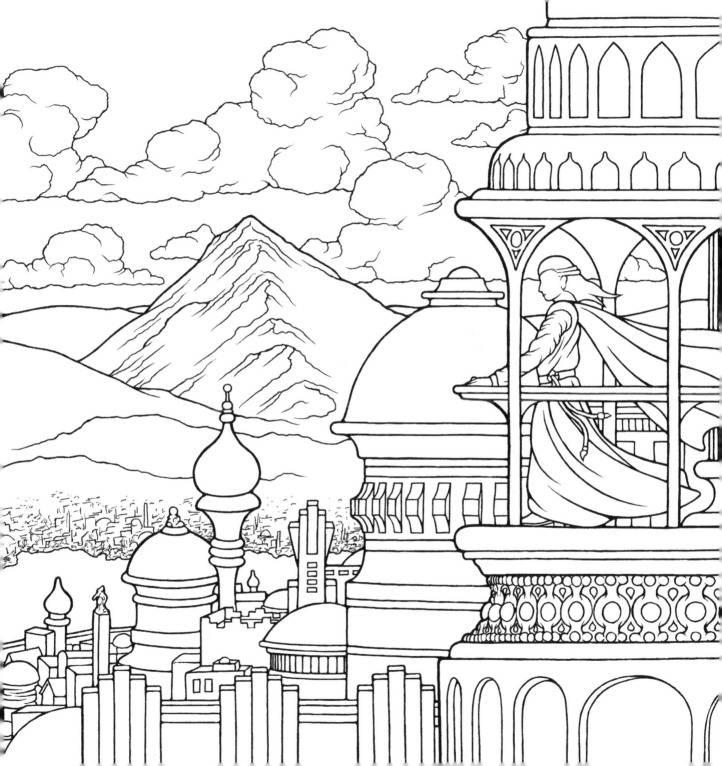

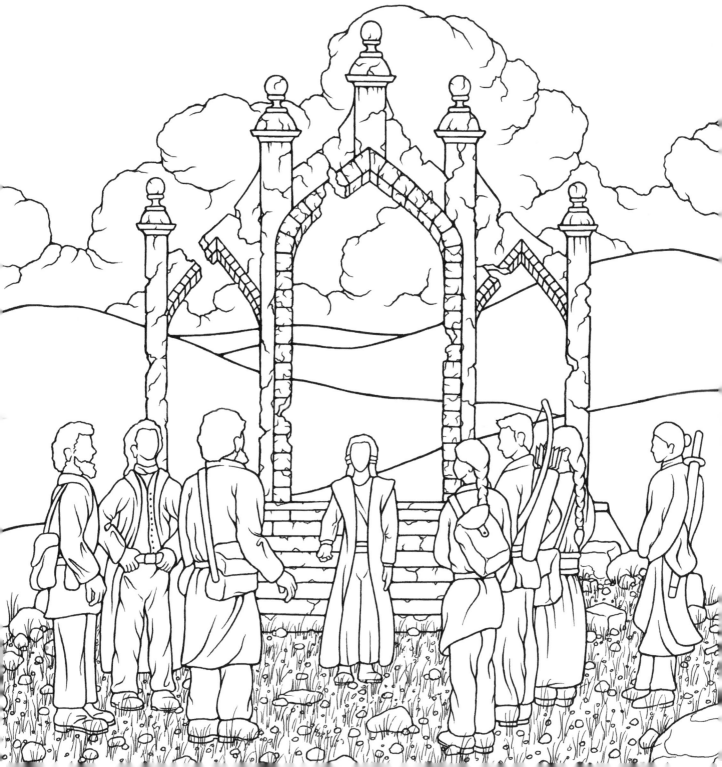

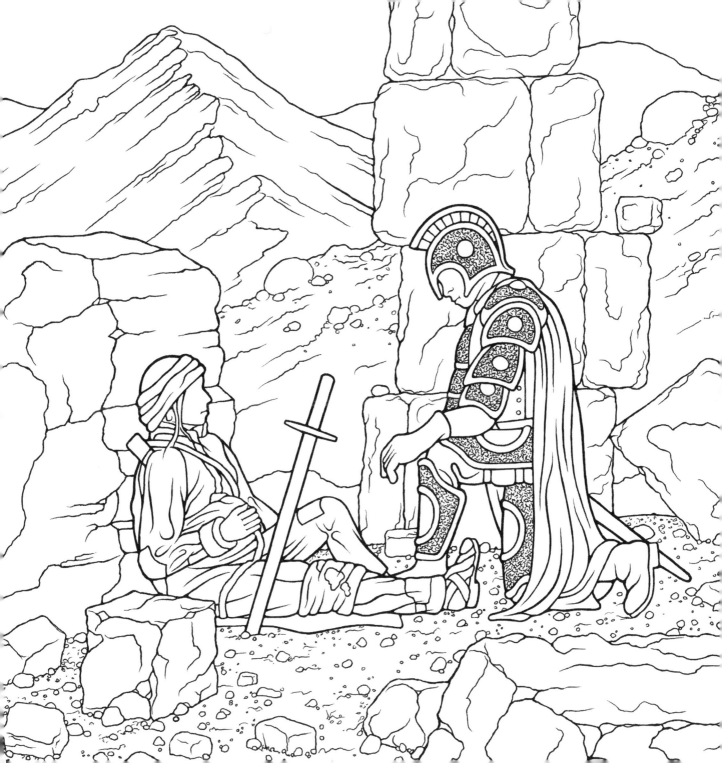

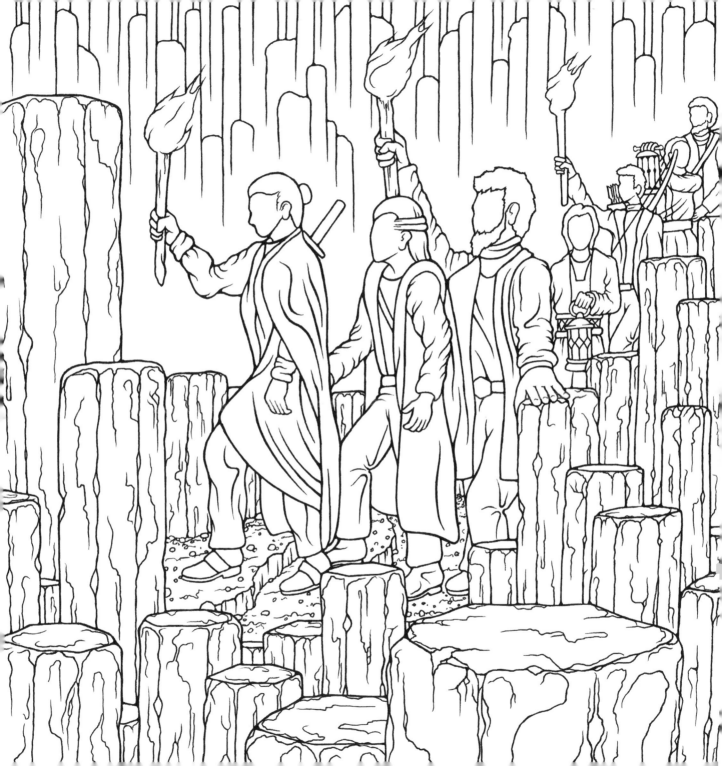

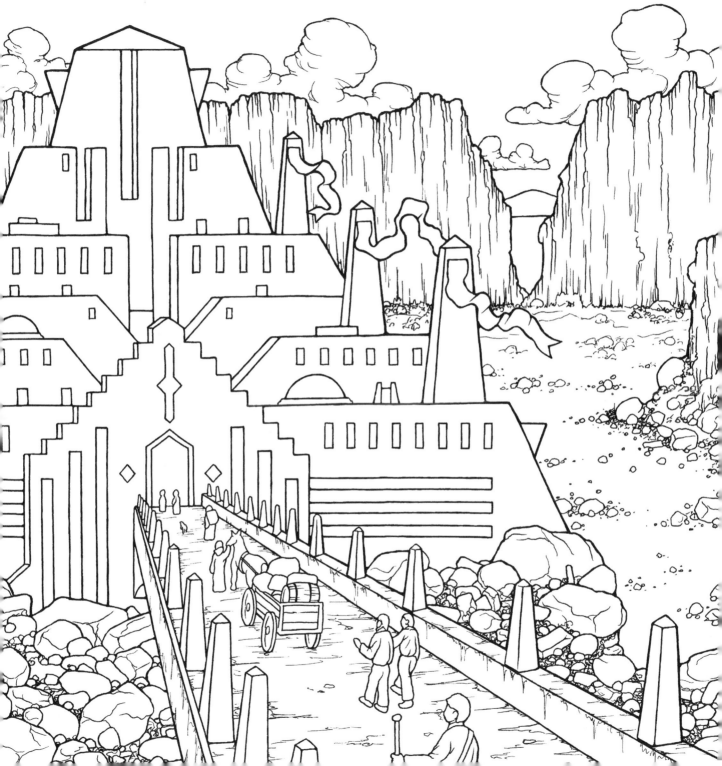

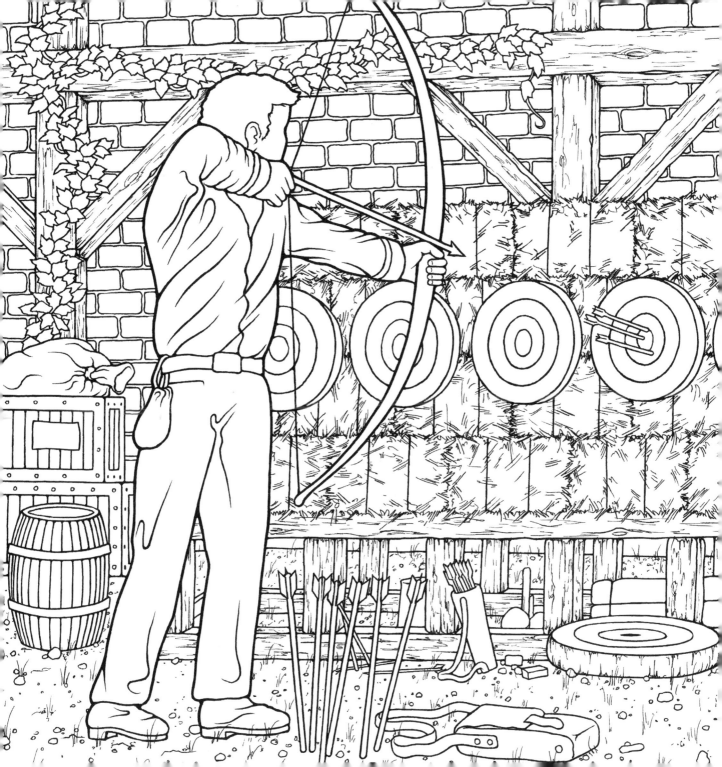

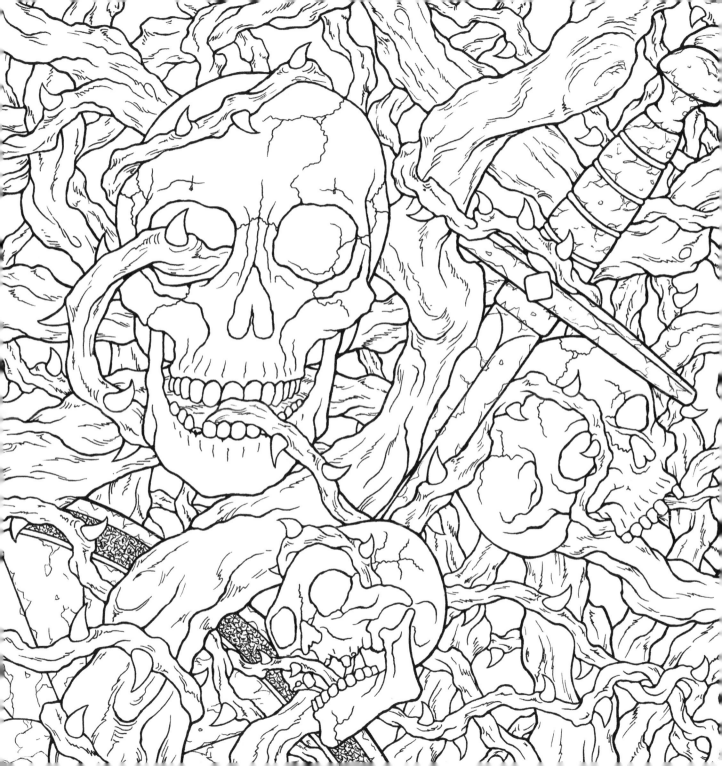

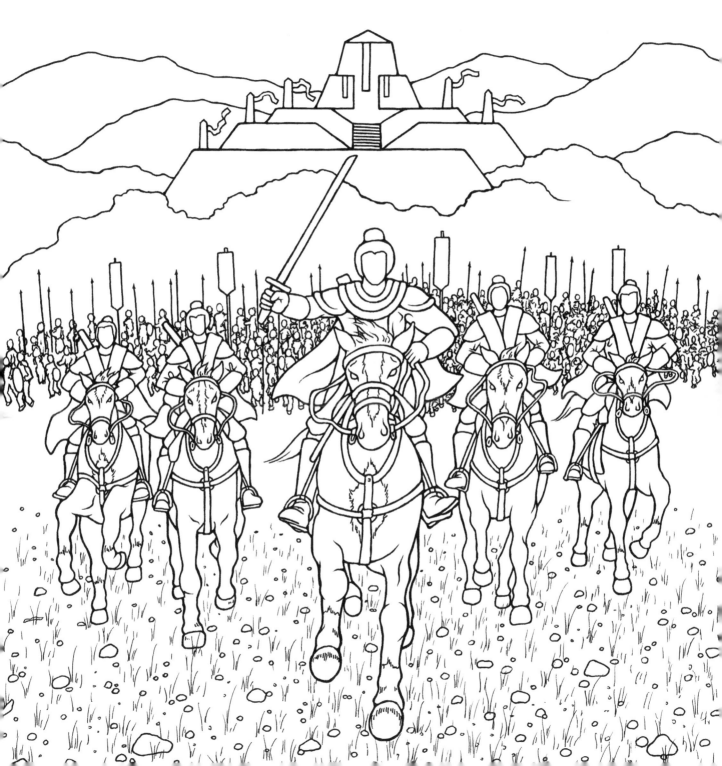

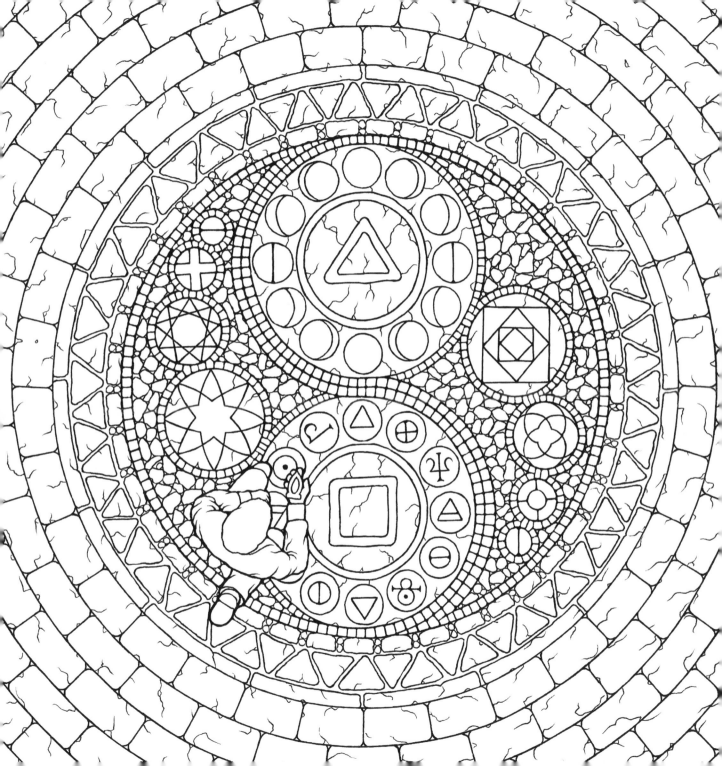

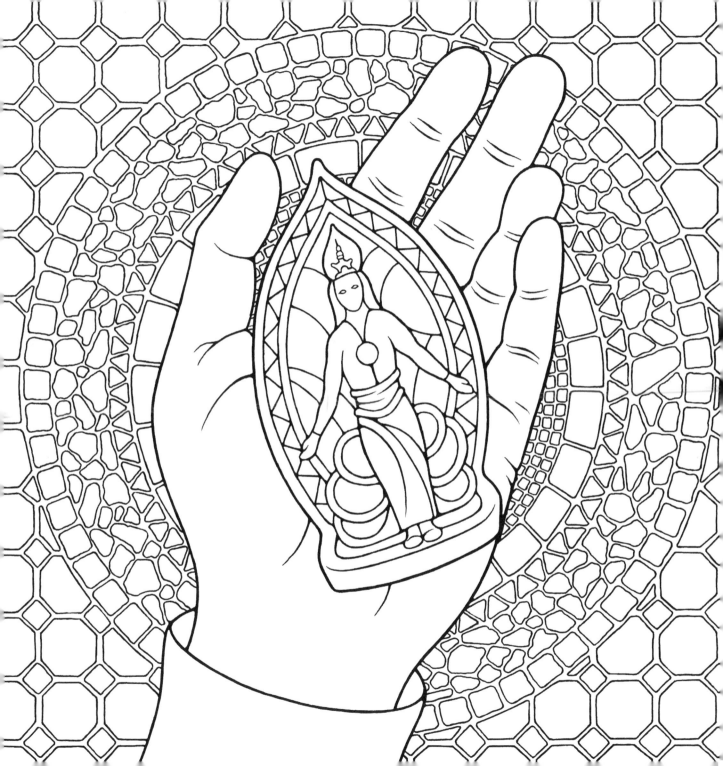

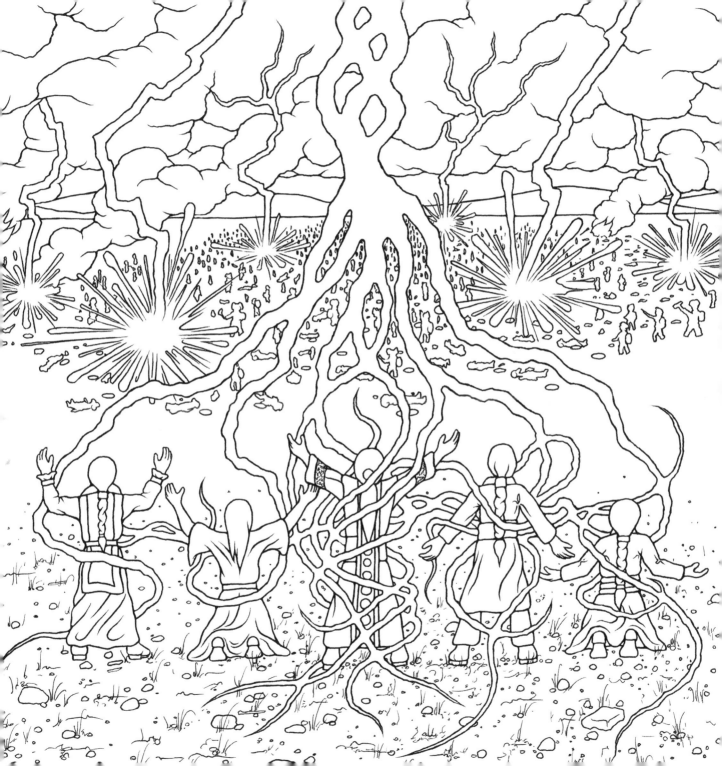

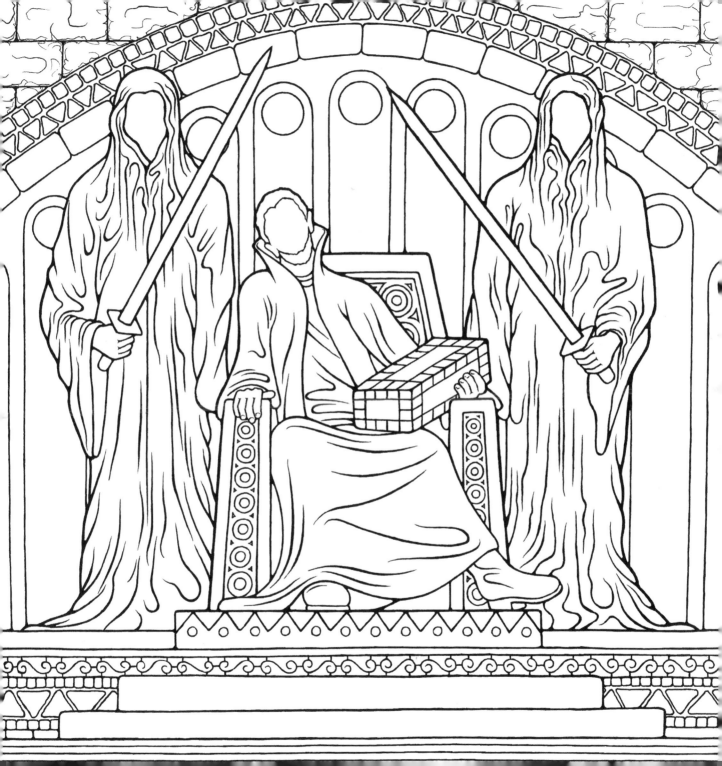

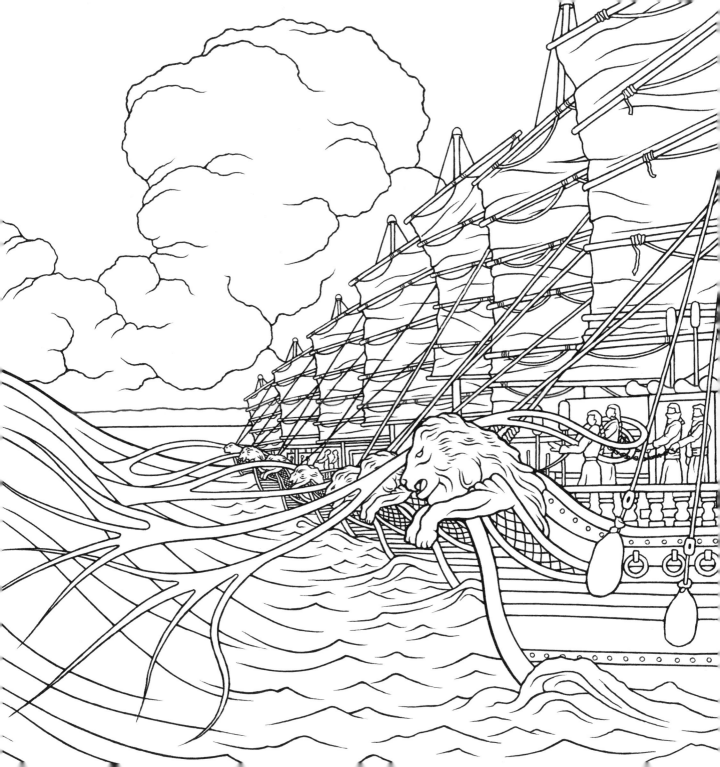

Live the life of a Bridgerton with a flick of your colored pencil!

PICK UP YOUR COPY TODAY!

adamsmedia
An Imprint of Simon & Schuster
A Paramount Company